W9-BXI-908

J. GARCIA

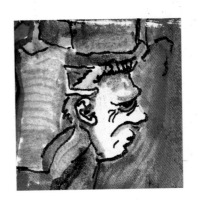

J. GARCIA

Paintings, Drawings, and Sketches

Edited by David Hinds
Foreword by Roberta Weir

CELESTIAL ARTS
Berkeley | Toronto

Copyright © 1992, 2005 by Jerry Garcia. All rights reserved. No part of this book may be reproduced in any form, except for the purpose of brief review, without written permission of the publisher.

Celestial Arts Publishing
PO Box 7123
Berkeley, CA 94707
www.tenspeed.com

Celestial Arts Books are distributed in Australia by Simon & Schuster Australia, in Canada by Ten Speed Press Canada, in New Zealand by Southern Publishers Group, in South Africa by Real Books, and in the United Kingdom and Europe by Airlift Book Company.

Cover art: *David,* 1990, pen and ink on paper by Jerry Garcia.
Taos Skyline, 2004, tie-dye origami watercolor by Ruth Ross and Claire Soucy.
Cover design by Toni Tajima
Text design by David Charlsen
Composition by ImageComp

Library of Congress Catalog Number 92-072066

First printing 1992

ISBN-10: 1-58761-230-5
ISBN-13: 978-1-58761-230-5

1 2 3 4 5 6 — 09 08 07 06 05

Printed in Singapore

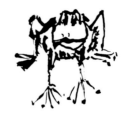

For Manasha,
with Love,
Jerry

My Brush with Jerry Garcia

"Jerry Garcia's dead."
"Yeah, that's what they'd like you to think."
—Mel Gibson to Julia Roberts in CONSPIRACY THEORY

Jerry once said, "A line on paper is like a note in the air. It's out there. And once it's out there, there's no taking it back." I believe this comment conveys the essence of Jerry's drawings and paintings. His images are not so much faithful renderings as they are animated strokes that dance across paper collecting into unselfconscious improvisations. His pen (or brush) wandered freely, taking him where it would.

Jerry's music accompanied many thousands of us on our respective life journeys through three decades, from the sixties to the nineties. However, I only became aware of Jerry's talents as a graphic artist in 1989. At this time I invited him to show his work at my gallery in Berkeley, California. In December of 1991 we opened a two-man exhibition at the Weir Gallery with Jerry Garcia and John Kahn to a deluge of enthusiastic fans overflowing the usually quite corner of Solano Avenue and Tacoma Street.

Since then I have had the privilege and opportunity to see hundreds of Jerry's drawings and paintings as they

passed through my hands on their way out into the world—sometimes to the tranquil homes of private collectors and sometimes to the crowded halls of public collections.

Jerry's mind was a virtual kaleidoscope where forms and ideas overlapped with impunity. He was supremely serendipitous, he made no apologies for his technique, and he had an unerring instinct for the symbiotic power of simple images. He kept his pens and sketchbooks with him at all times, scribbling and sketching constantly—on his tour bus, during business meetings, at night, during the day—wherever and whenever he felt the images spill from his mind onto the paper. In addition, he spent long hours with his friend John Kahn working on paintings and etchings at John's home.

Just as his musical style echoes the homely heartstrings of American Bluegrass, so Jerry's drawings reveal their origins in the irreverent cartoons of Ignatz and Krazy Kat, Tugboat Willie, and the brilliance of Max Fleischer's "Out of the Ink Bottle," which we discovered we had both loved as children. And although Jerry claimed he never thought about it much, I know he had great interest and respect for the revered artists of his time—Picasso, Ernst, de Chirico, Klee.

Having been born in the same year, Jerry and I shared a kindred bond. Also, Jerry appreciated my work, which

forged an artistic affinity between us that allowed me to preserve our connection despite heavy demands on his creative energy throughout his career.

Jerry always appeared to enjoy visiting the gallery and seemed genuinely delighted to see the formal presentation of his drawings and paintings.

The gallery was also a venue for meeting unsuspecting fans. One evening after letting in a young couple long past closing hours, I noticed Jerry standing discreetly at the back of the gallery where he could hear them without being seen. As the appreciative pair arrived at the last piece in the show, they rounded a corner and came upon the artist himself. There was a burst of delighted surprise and much laughter from them. And for Jerry, it was an occasion of unusual privacy with his admirers that he thoroughly, and modestly, enjoyed.

I loved talking with Jerry about art and I tried to inspire him to pursue some serious study. I knew he had attended the San Francisco Art Institute before becoming a professional musician. He once told me, "Art was probably my most civilized aspiration. But music seduced me." And from that time onward art became a private activity—and one at which he was gifted, productive, and largely unknown. No need to prove anything, just a serendipitous stroll with line and color down a hall of mirrors within his own consciousness.

Sometimes we worked together, hiring a model and drawing from life. "I don't want to work at this," he once told me. "I'm just doing it totally for my own amusement and pleasure. I don't need any more fame."

Our last meeting was in 1995 at his home in Tiburon. Jerry talked about art, music, and death. "The dead ought to be cremated. It's less messy and doesn't take up so much space." I asked him if he thought the living should wait for the soul of the deceased to detach from the body. He looked down at his own body and pinched at his tee shirt. "Stick around for this? You've got to be kidding! I'm dead—I'm outta here!"

From 1990 until his death, I learned to accept Jerry's self-deprecating self-description, and I embraced his unpretentious visual style just as it was. Jerry left about a thousand drawings and paintings—not bad for a guy who was just enjoying himself. He may not have evolved into the classically trained, disciplined artist I had once envisioned. However, he left a lively and eccentric oeuvre that sparkles with spontaneity and demonstrates the breadth and abundance of his special creative spirit.

Knowing Jerry altered my life, as it did for anyone who was fortunate enough to share intimate, infinite time with him. And, as he was fond of saying, I got no problem with that!

Roberta Weir
January 2005
Dexter, Oregon

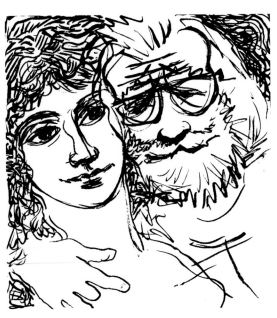

Illustration © by Roberta Weir

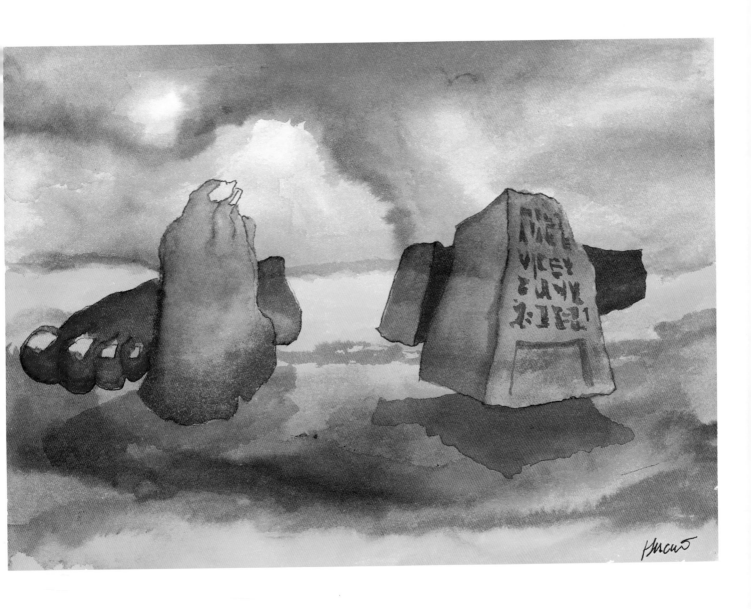

Hieroglyphics
10" x 7"
Ink and Watercolor *13*

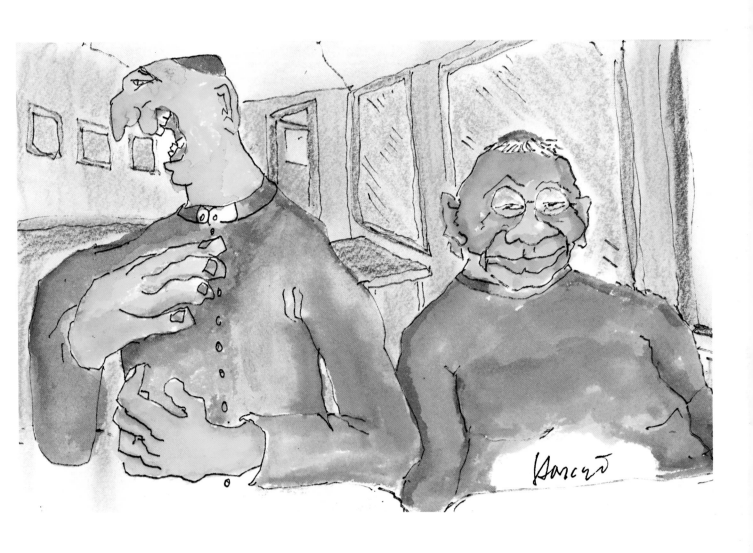

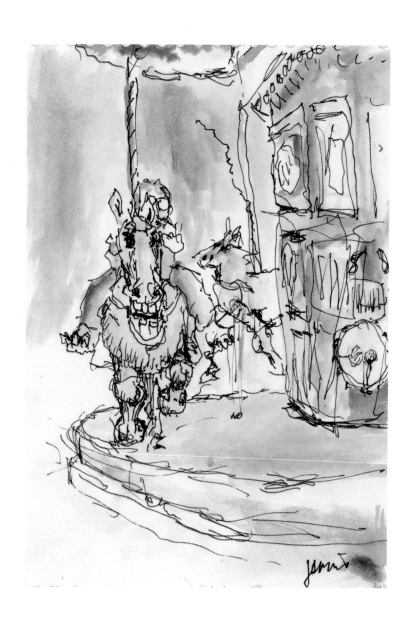

Carousel 1990
4" x 6"
16 Ink and Watercolor

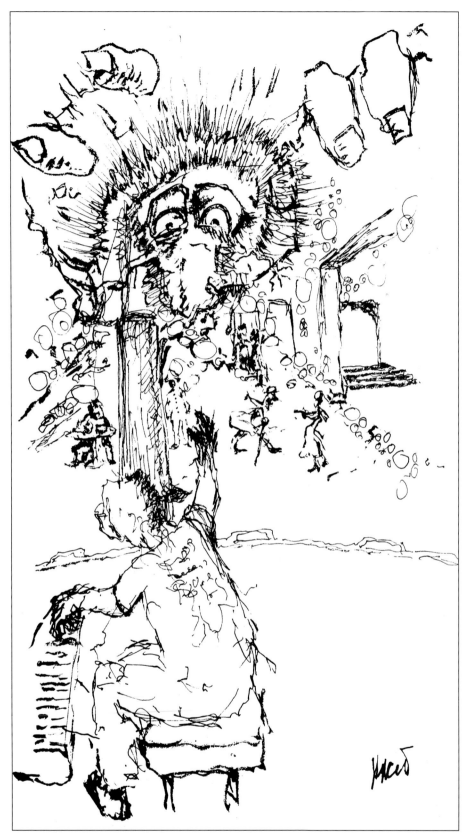

Big Bird breaking through from another reality to get Mr. Roger's piano player.

1990
5" x 8"
Ink 17

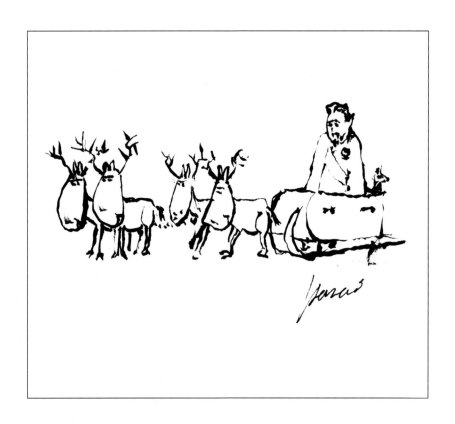

Dracula-Claus 1990
5" × 3"
18 Ink

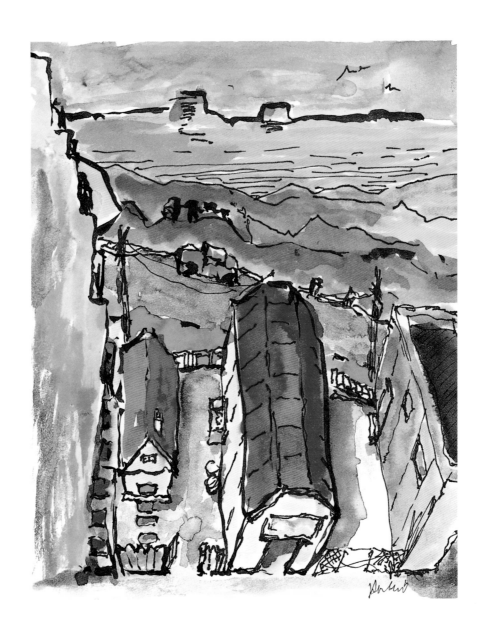

Overlooking the Desert 1991
4" x 6"
Ink and Watercolor *19*

Poet Absorbs the War 1991
9" x 12"

20 Watercolor

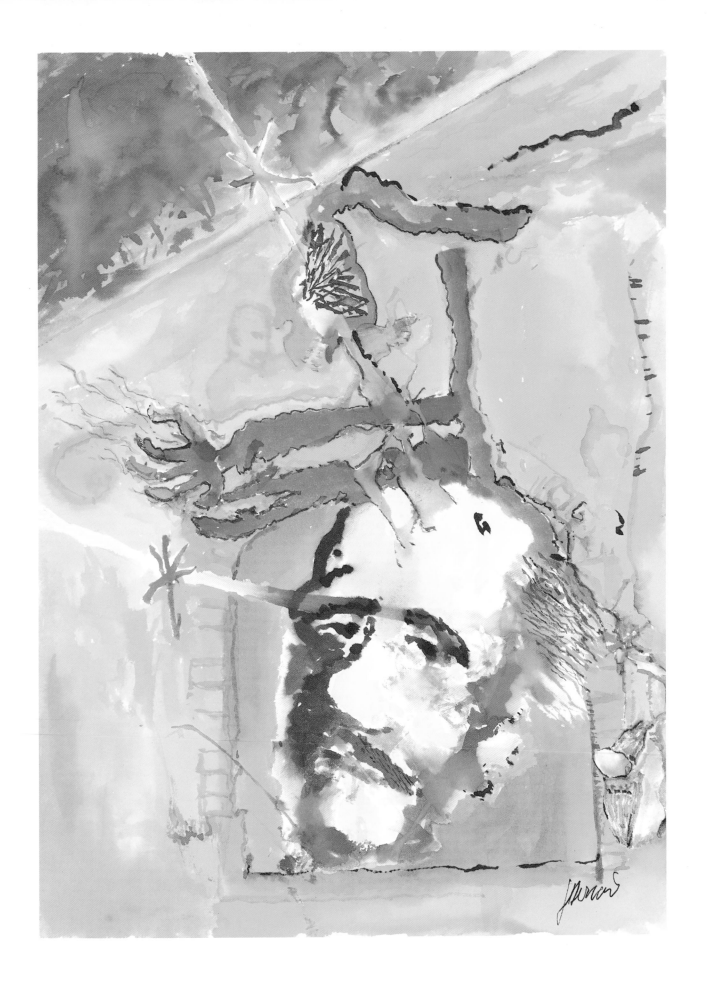

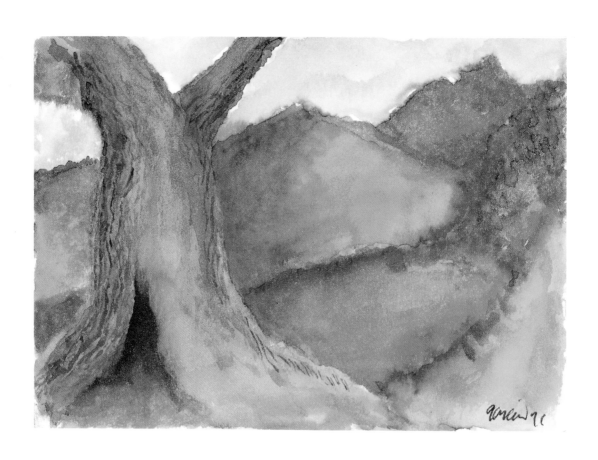

Green Landscape 1991
6" x 4"
22 Watercolor

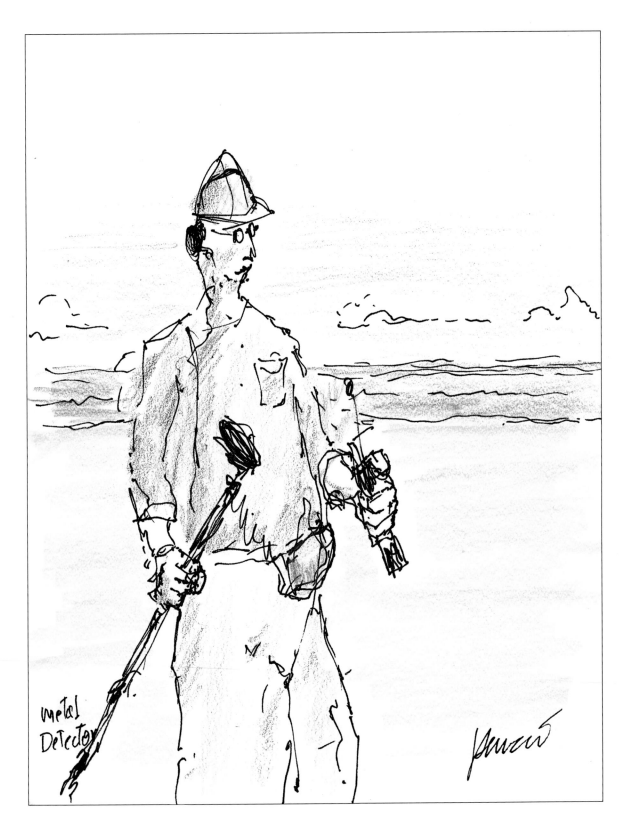

metal
Detector

Metal Detector 1991
6" x 8"
Ink and Colored Pencil *23*

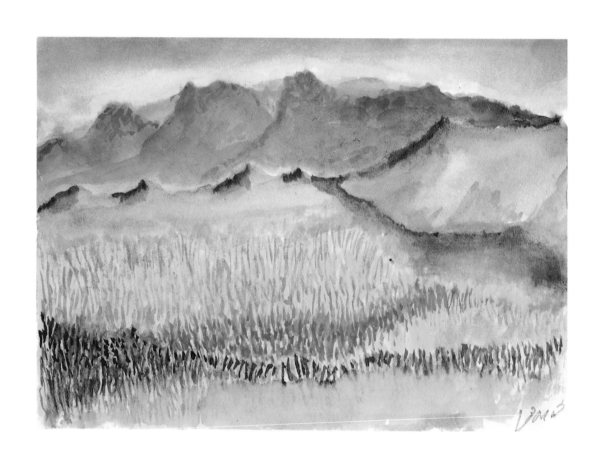

Red Meadow 1991
6" x 4"
Watercolor

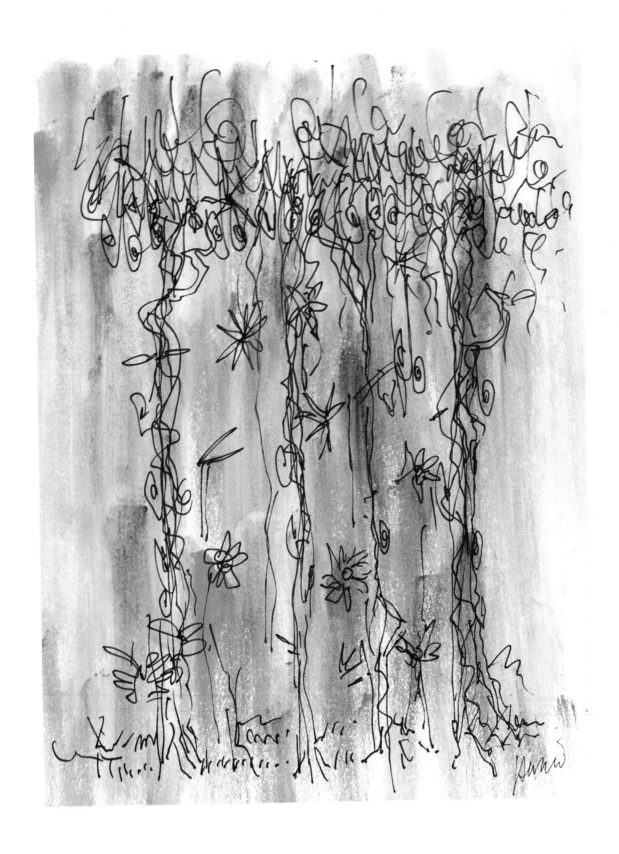

Banyan Trees 1991
6" x 8"
Ink and Watercolor 25

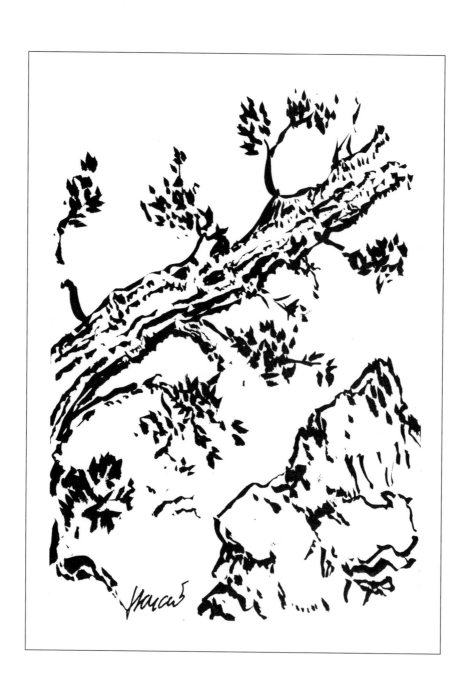

Pine and Rock 1991
4" x 6"
26 Ink

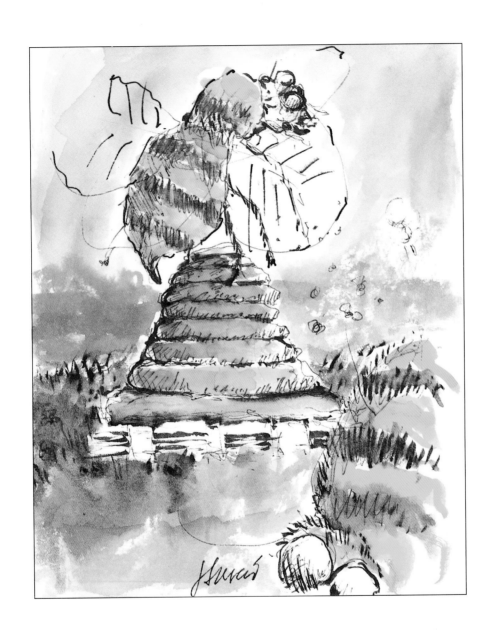

Bee Hive 1991
4" x 6"
Ink and Watercolor 27

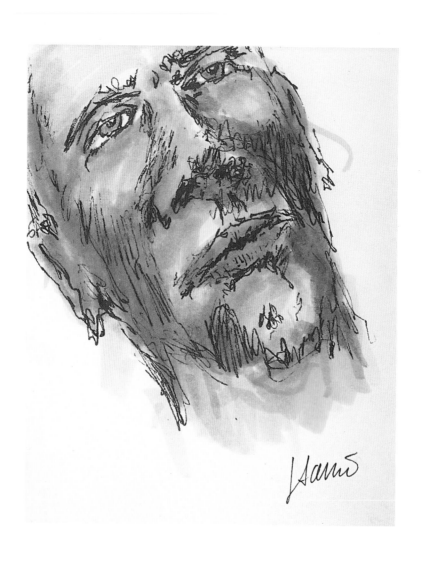

Blue-Eyed Man 1986
4" x 6"
28 Ink and Colored Marker

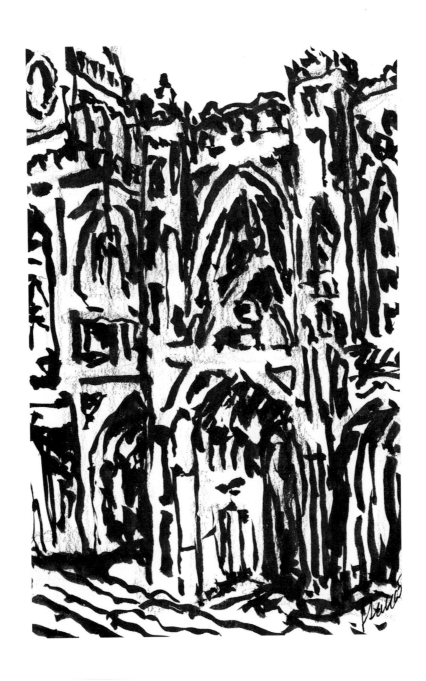

After Monet 1990
4" x 6"
Ink 29

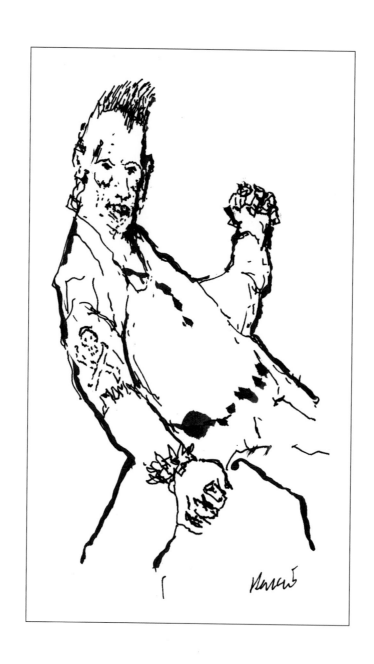

Yo! 1990
4" × 6"
30 Ink

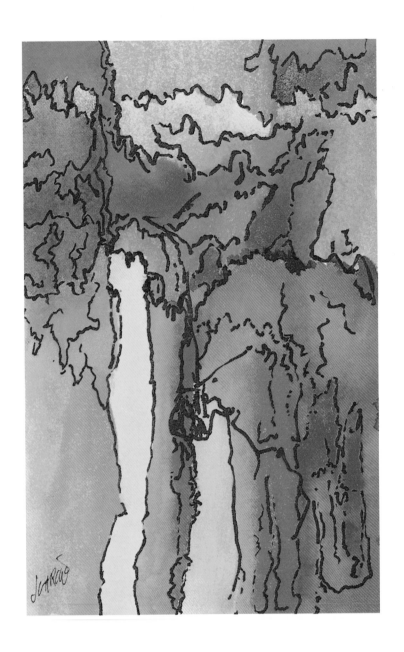

Volcano 1990
4" x 6"
Ink and Watercolor *31*

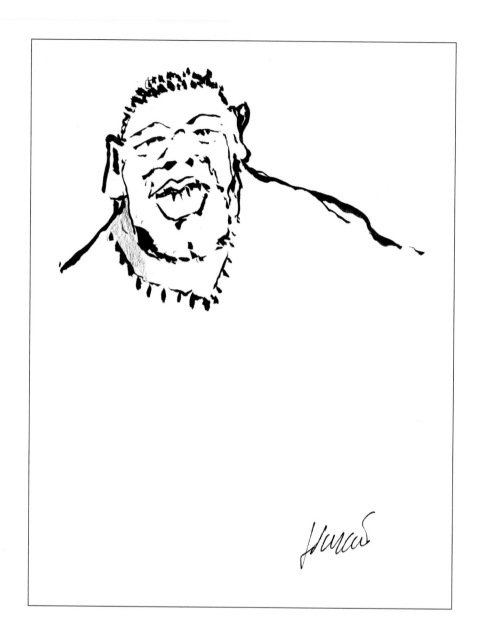

Homeboy 1990
4" x 6"
32 Ink

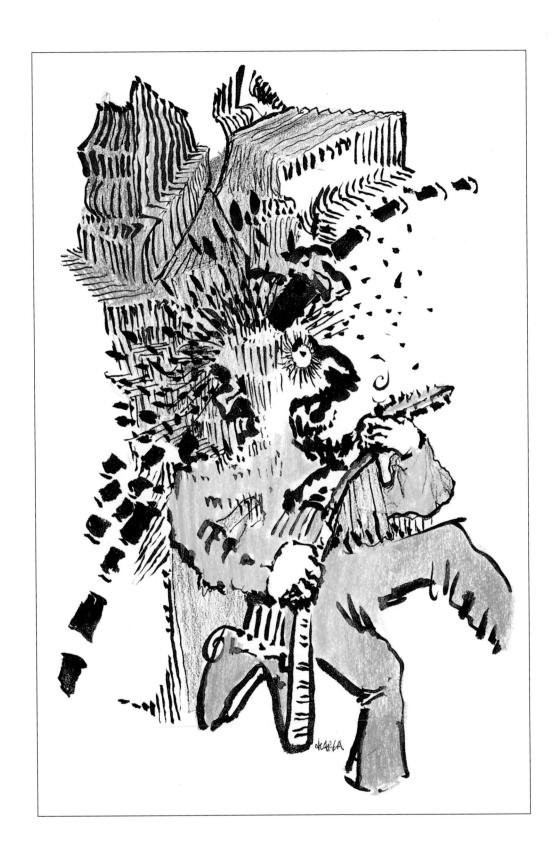

Wired Crossroads 1990
5" x 8"
Ink and Colored Pencil 33

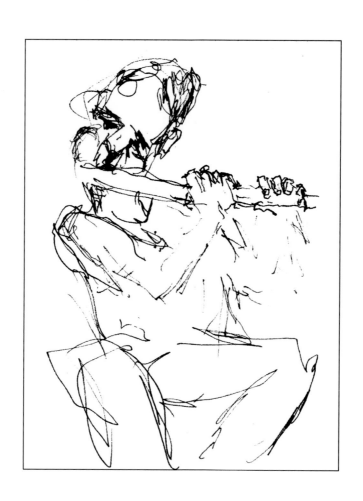

Flautist 1986
4" x 6"
34 Ink

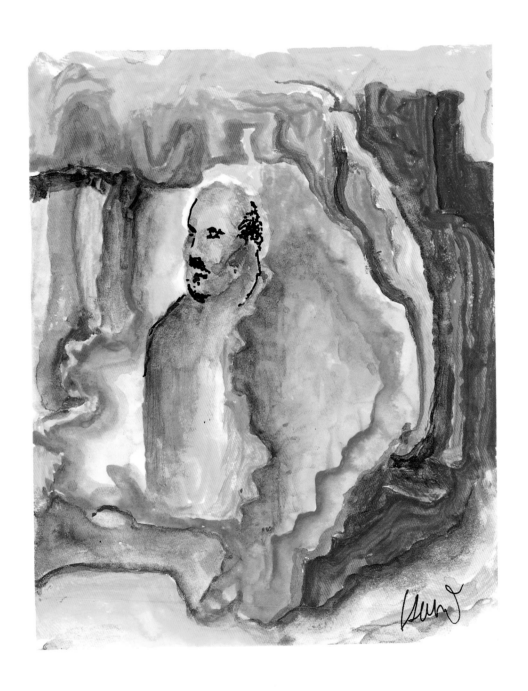

Man 1990
4" × 6"
Ink and Watercolor *35*

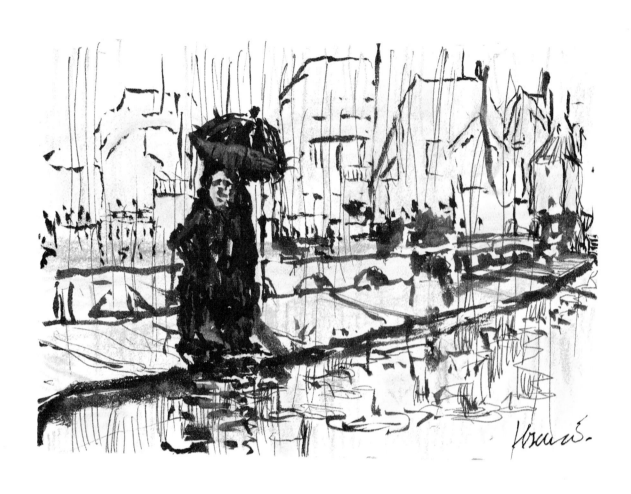

Paris in the the Rain 1991
6" x 4"
36 Ink and Watercolor

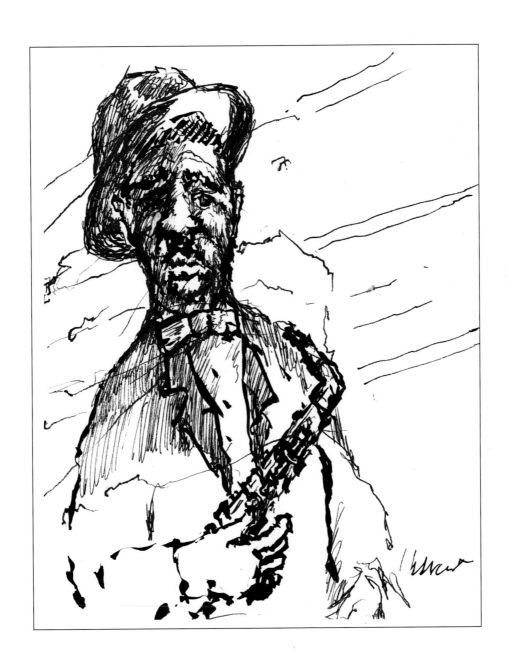

Zoot 1991
4" x 6"
Ink *37*

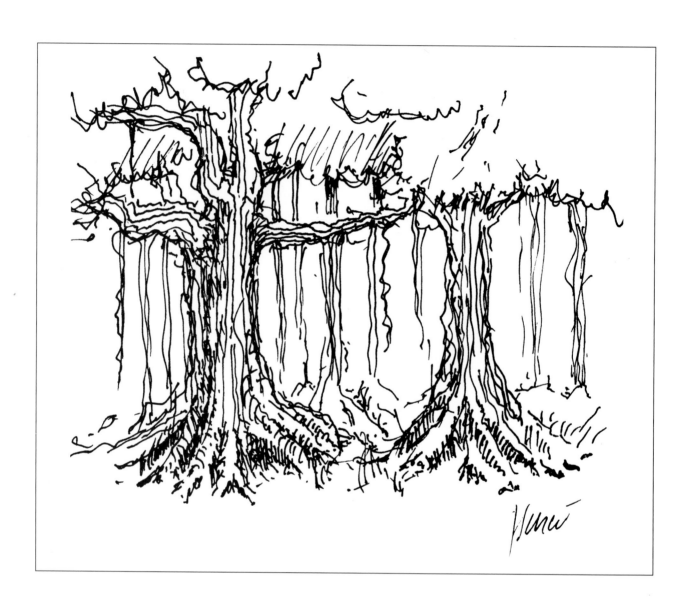

Banyan Forest 1991
6" x 5"
38 Ink

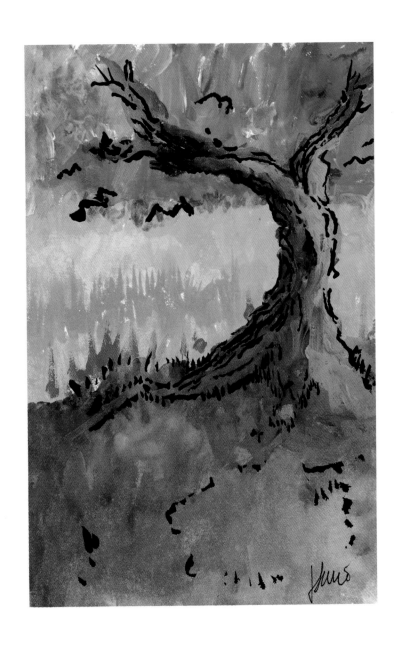

Van Gogh's Tree 1990
4" x 6"
Ink and Watercolor *39*

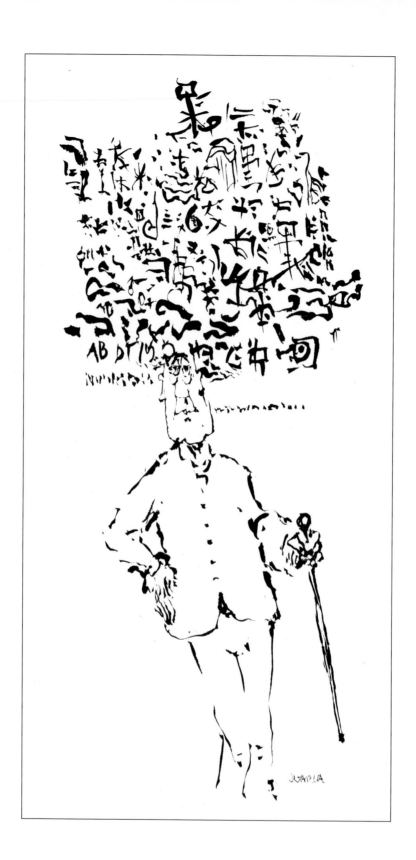

Abstracted 1990
4" x 8"
40 Ink

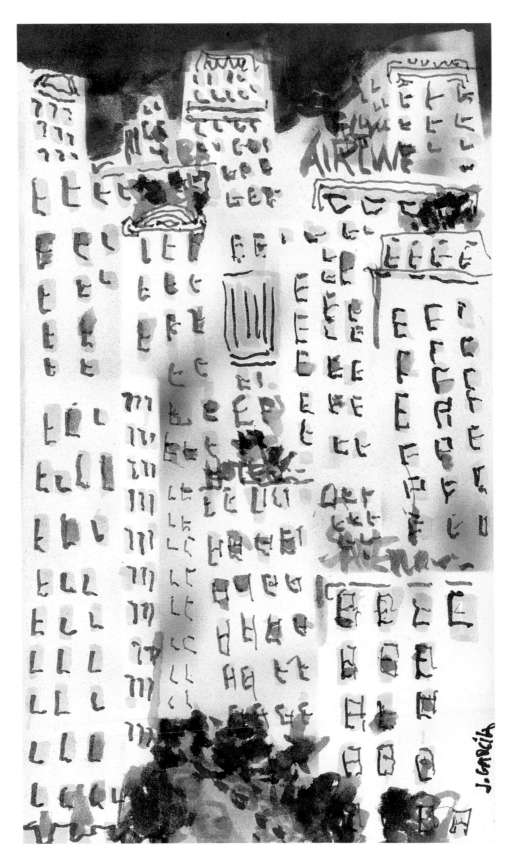

New York, NY 1985
5" x 8"
Airbrush Colored Marker *41*

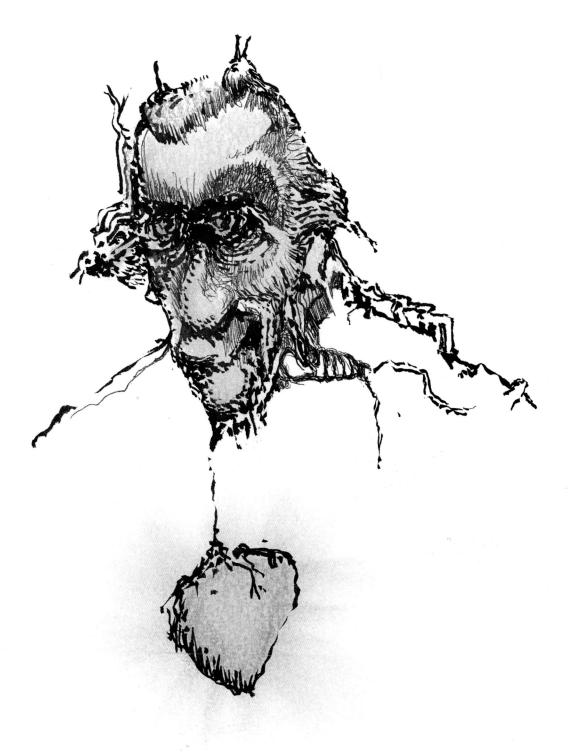

Thirsty 1991
7" x 9"
Ink and Watercolor 43

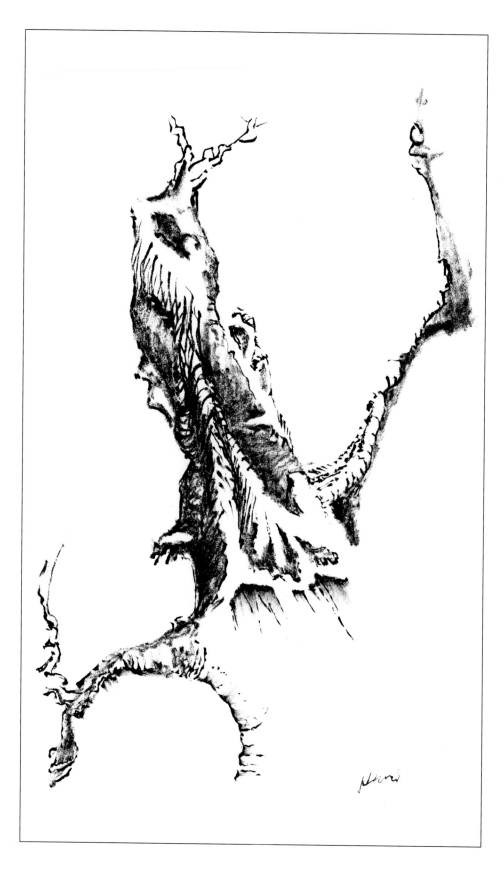

Not Quite Wood 1989
5" x 7"
Ink

44

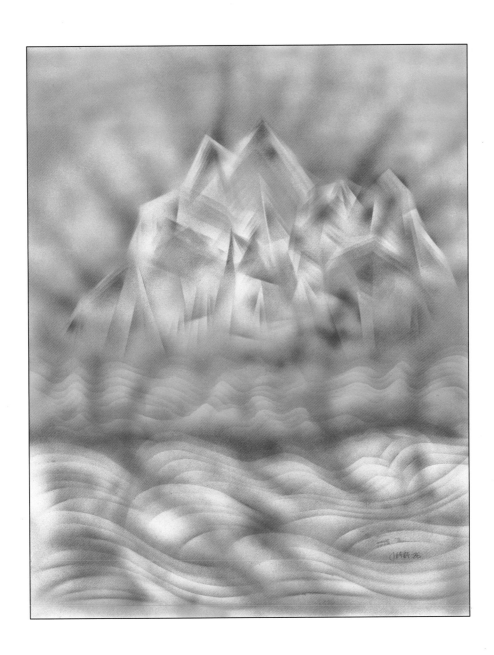

The Blue Iceberg 1986
19" x 24"
Airbrush Acrylic *45*

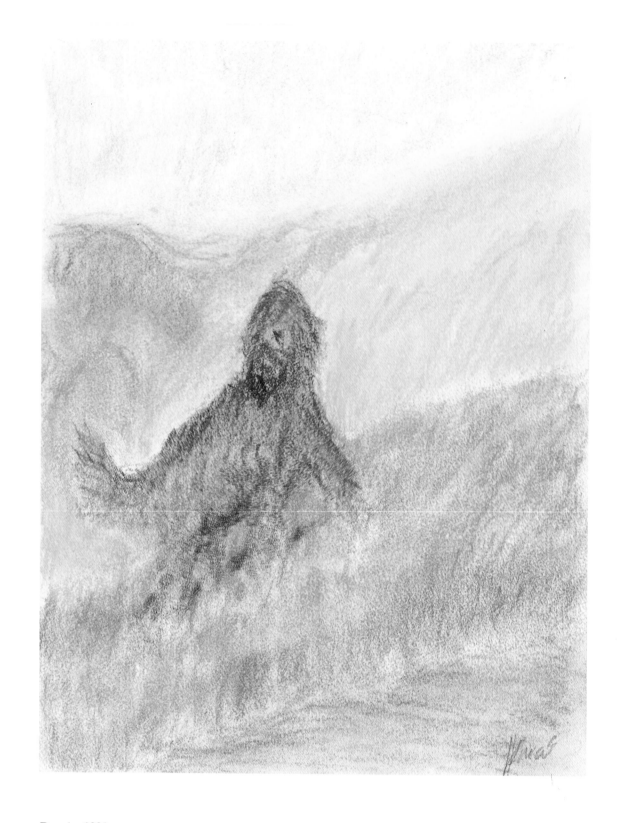

Doggie 1991
6" x 8"
46 Colored Pencil

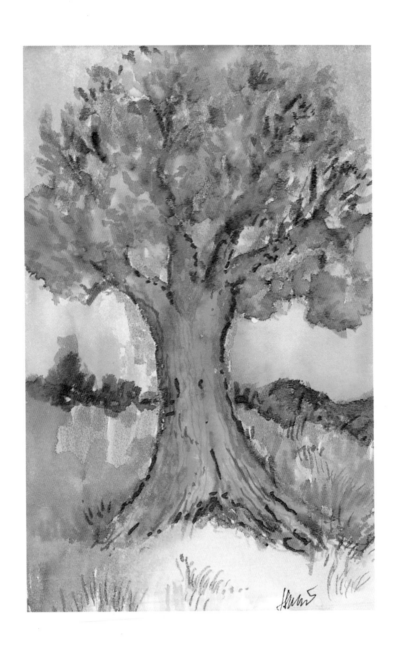

Oak Tree 1990
4" x 6"
Watercolor *47*

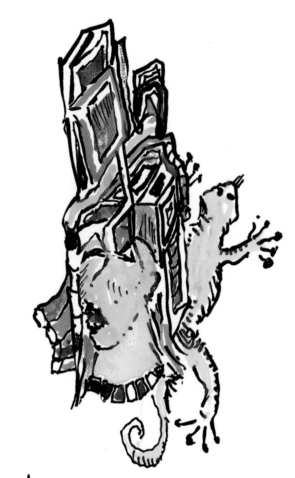

Lady w/ Elaborate Headress & gekko

Lady with Elaborate Headress and Gekko 1990
4" x 6"

48 Ink and Watercolor

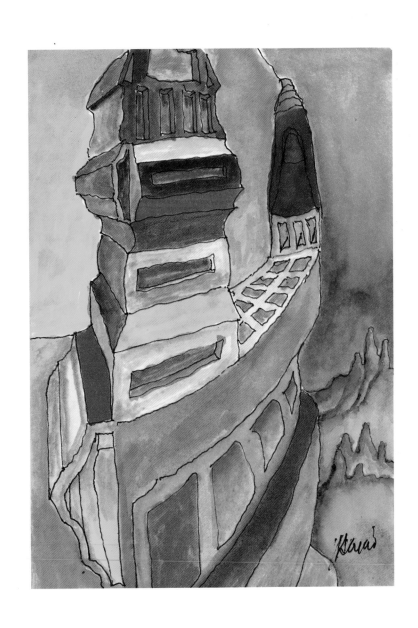

Untitled 1990
4" x 6"
Ink and Watercolor *49*

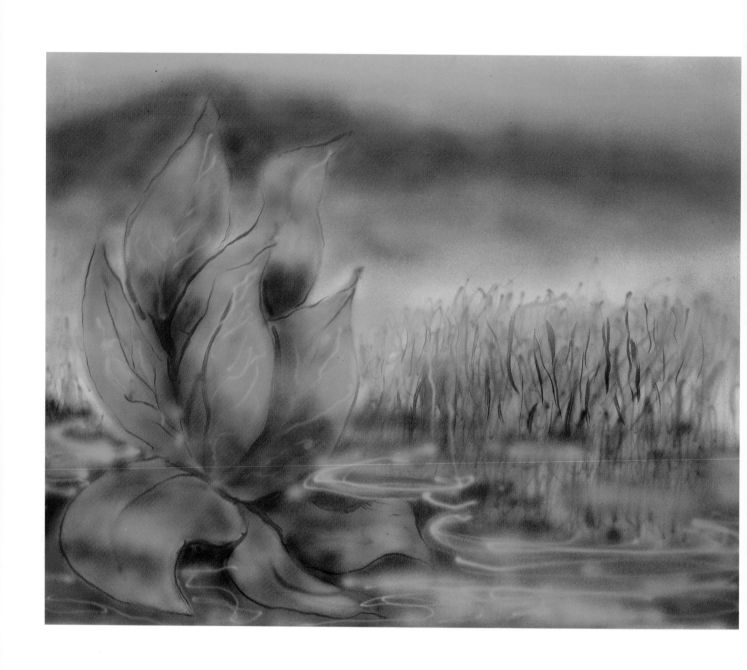

Wetlands II 1986
24" x 19"
Acrylic Airbrush

50

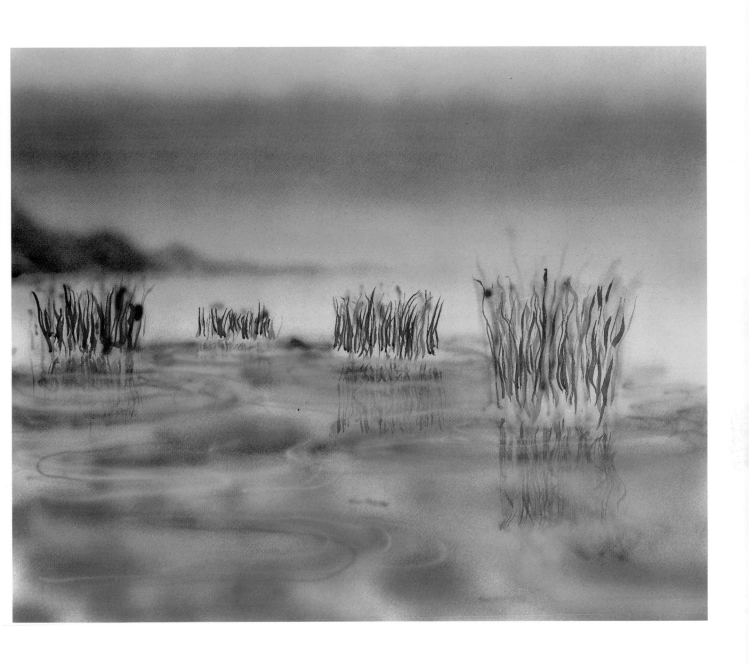

Wetlands I 1986
24" x 19"
Acrylic Airbrush *51*

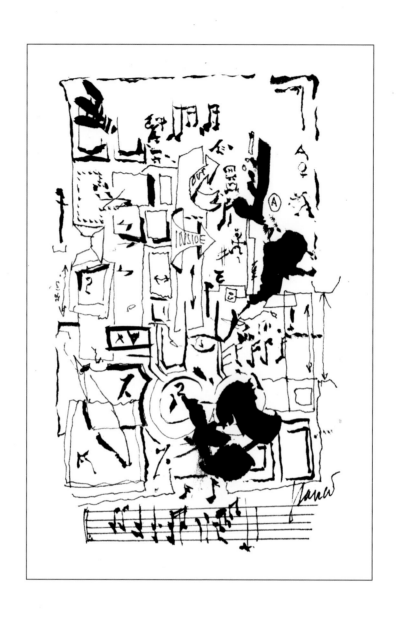

Uncorrected Manuscript 1989
4" x 6"
52 Ink

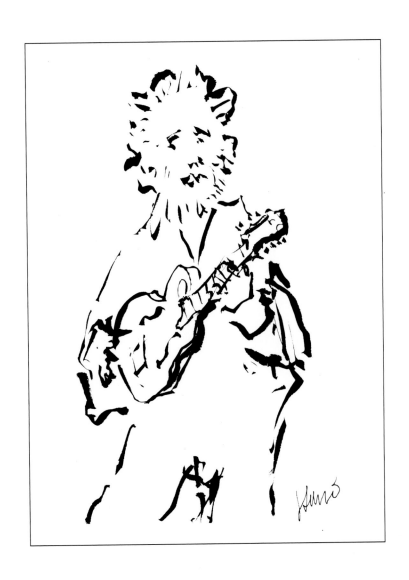

David 1990
3" x 5"
Ink 53

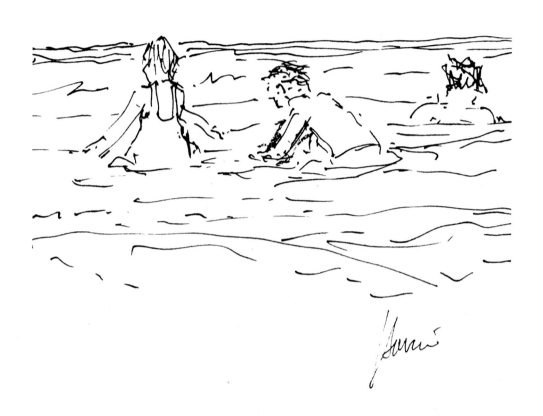

Bathers 1990
6" × 6"
54 Ink

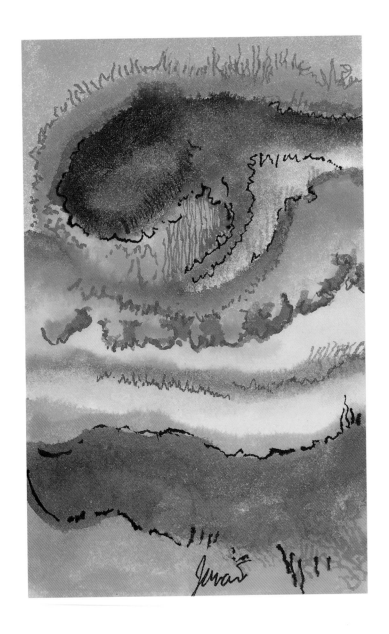

Untitled 1989
4" x 6"
Ink and Watercolor 55

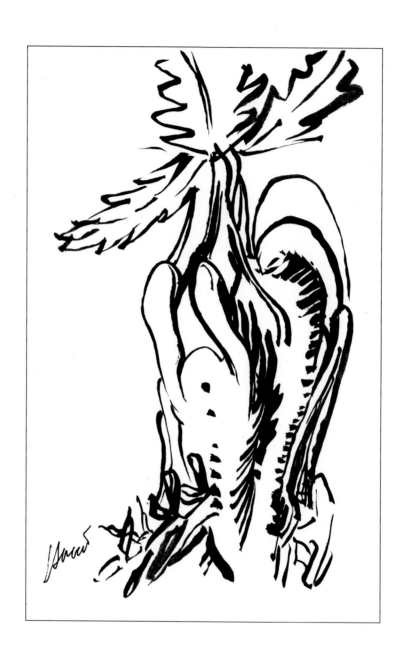

Plant Person 1990
4" x 6"
56 Ink

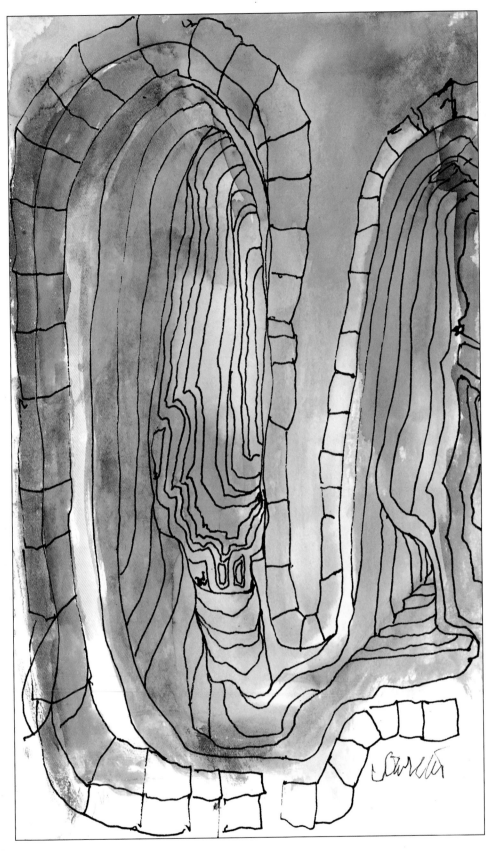

More Arches 1990
5" x 8"
Ink and Watercolor 57

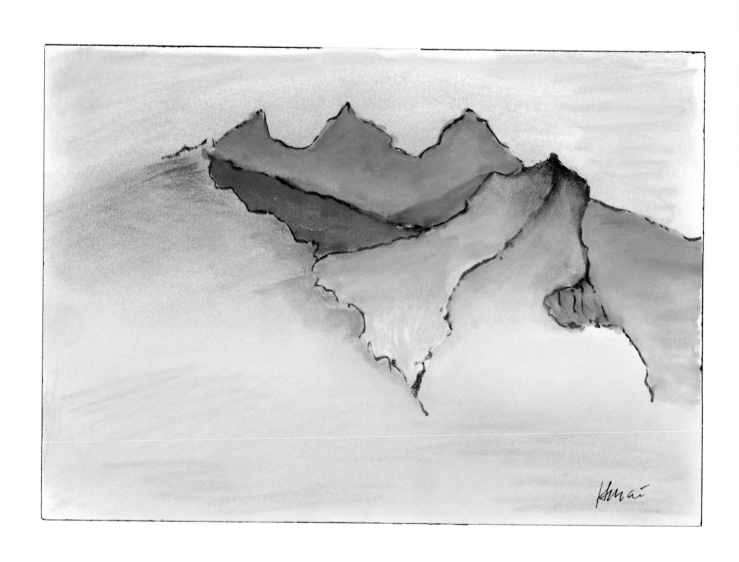

Landscape 1991
10" x 7"
Watercolor

58

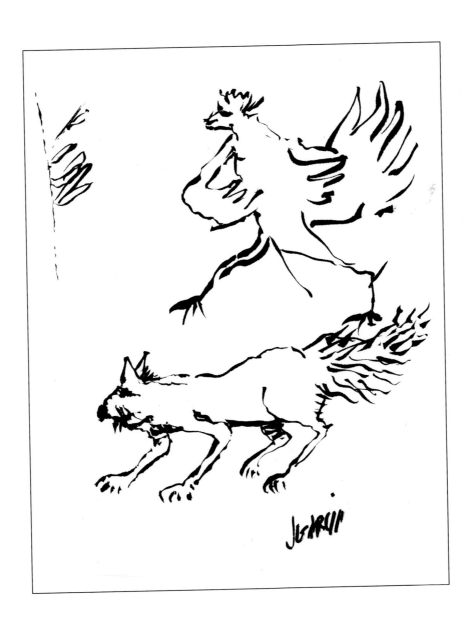

Chicken and Cat 1990
4" x 6"
Ink 59

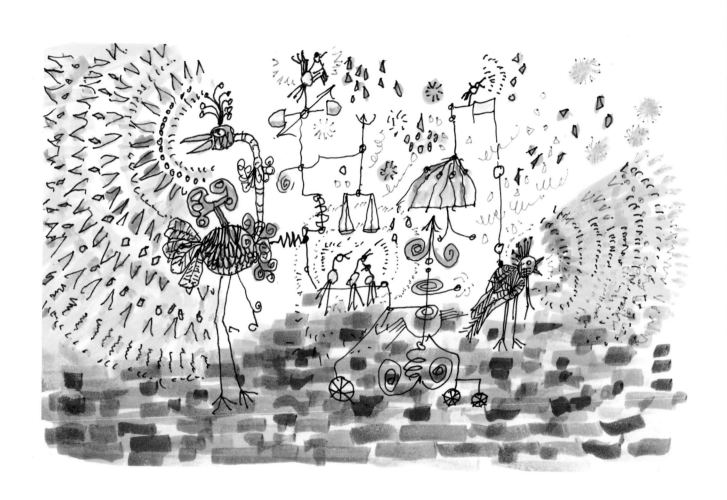

Like the Twittering Machine (for Paul Klee) 1985
7" x 5"
Ink and Colored Marker

60

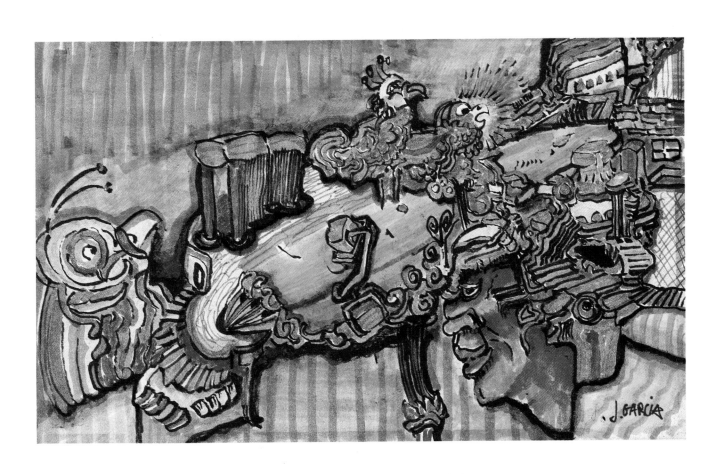

Birdland 1985
7" x 5"
Ink and Colored Marker 61

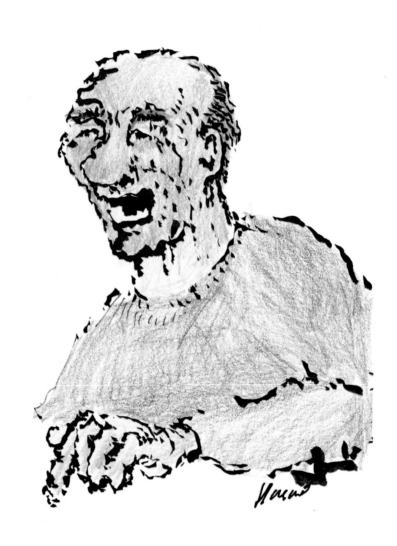

Bukowski 1991
4" x 6"
62 Ink and Colored Pencil

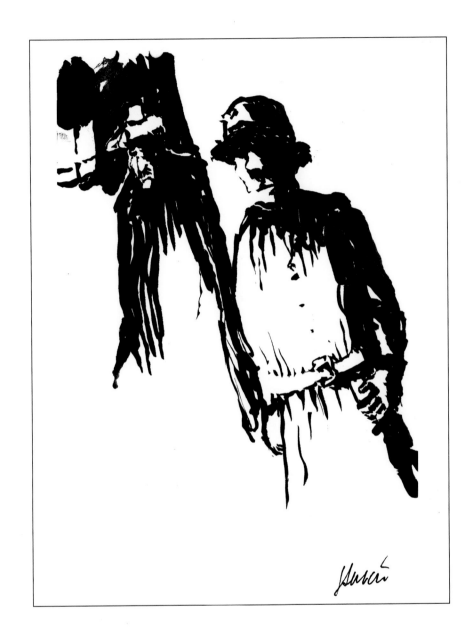

Film Noir 1990
4" x 6"
Ink 63

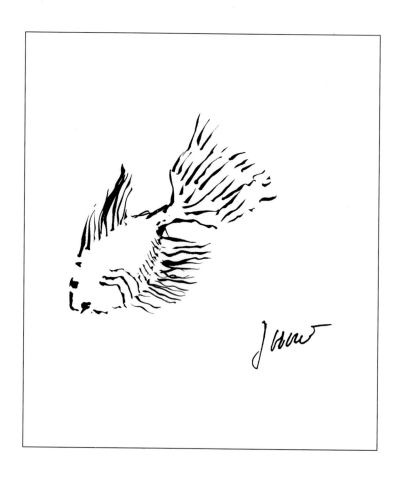

Little Fish 1991
3" x 3"
64 Ink

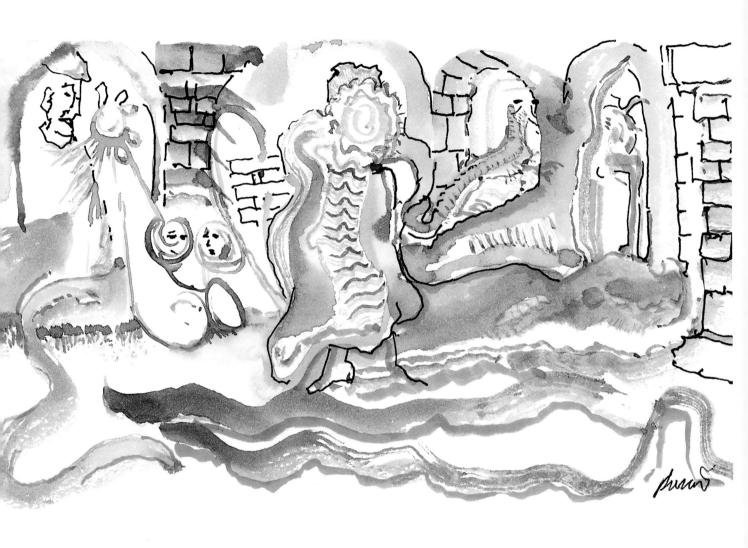

Courtyard Performance 1991
8" x 5"
Ink and Watercolor 65

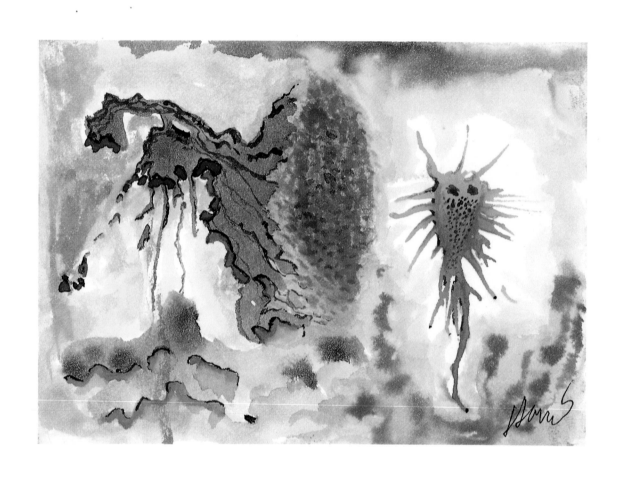

Thistle Ghost 1991
6" x 4"
Watercolor

66

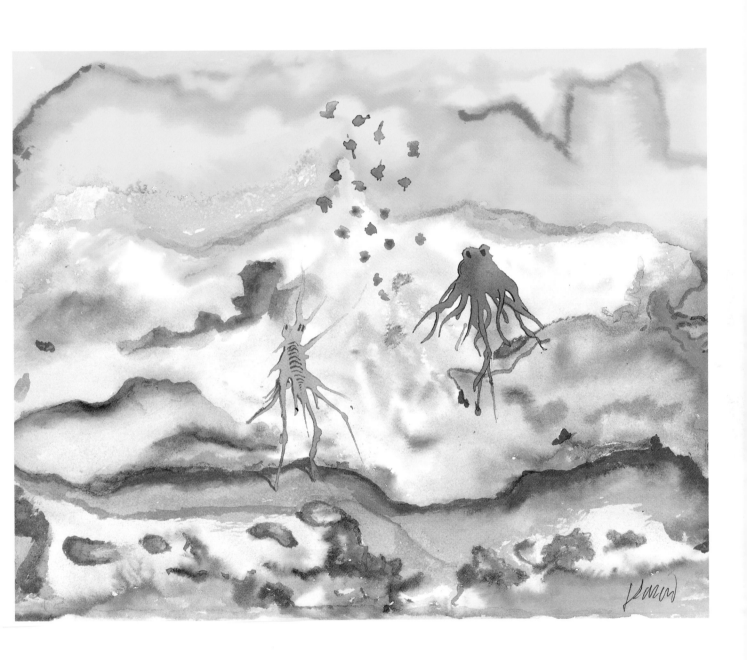

Neighbors 1990
12" x 9"
Watercolor 67

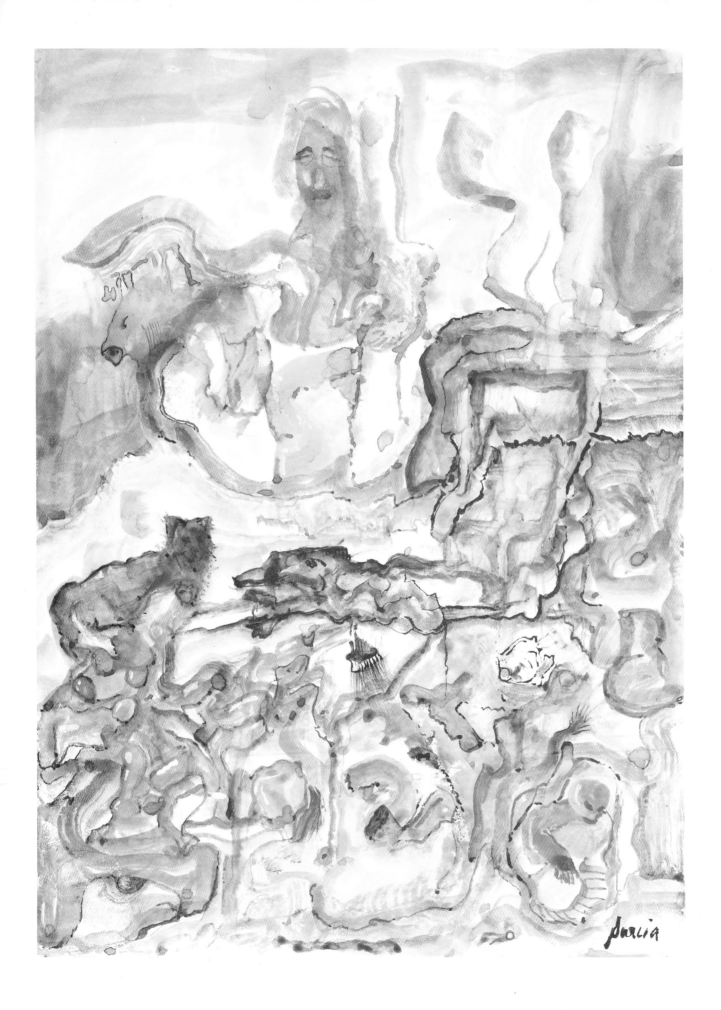

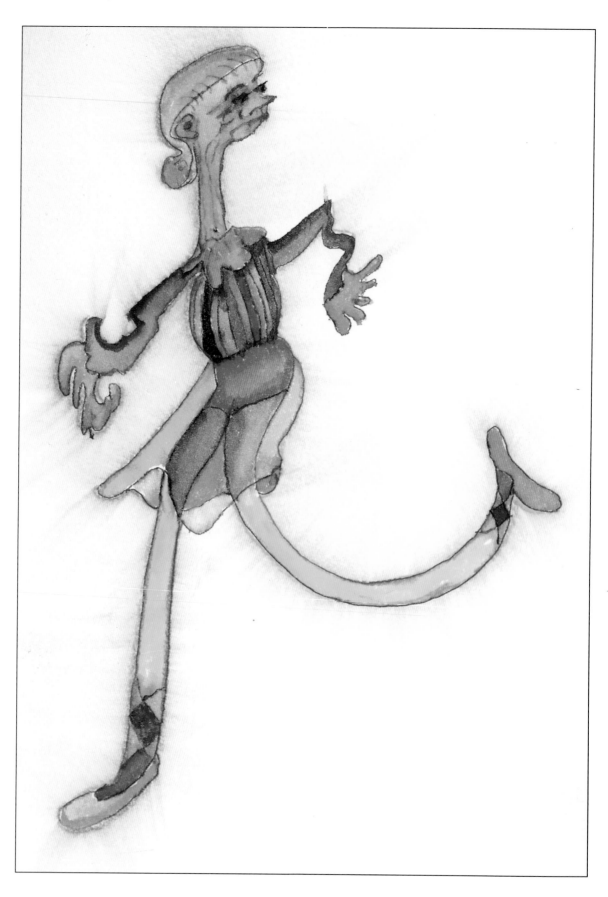

Lady with Argyle Socks 1991
6" x 9"
Ink and Watercolor

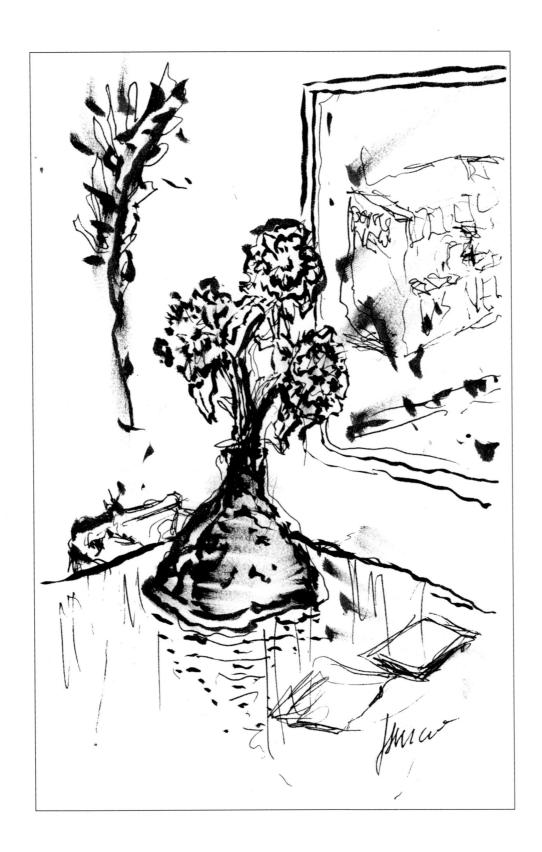

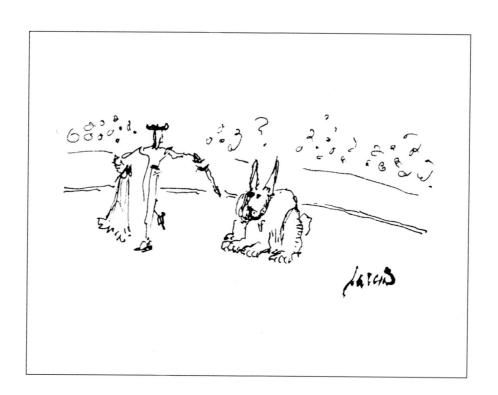

At the Bunny Fights 1990
5" x 3"
72 Ink

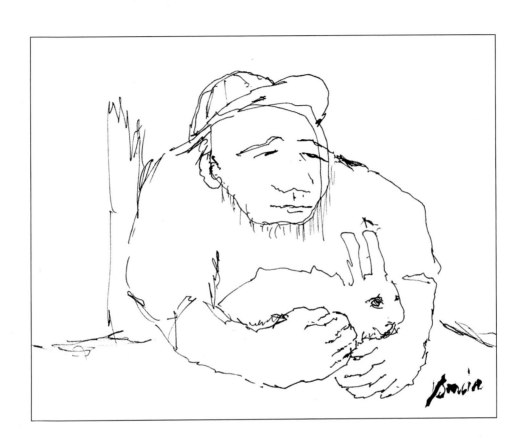

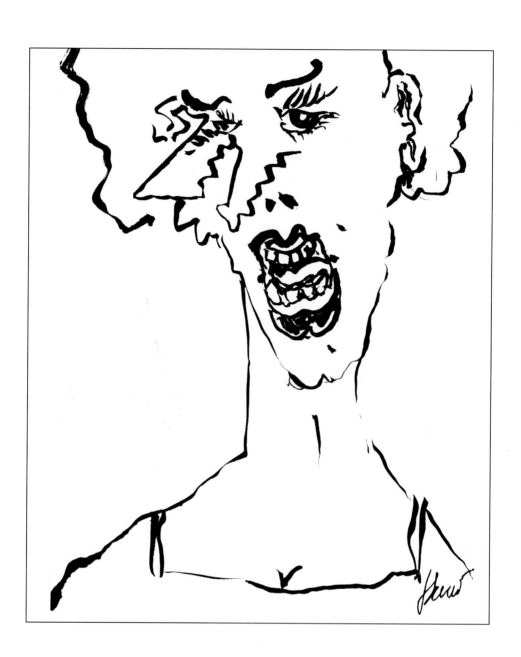

Scold 1991
5" x 6"
74 Ink

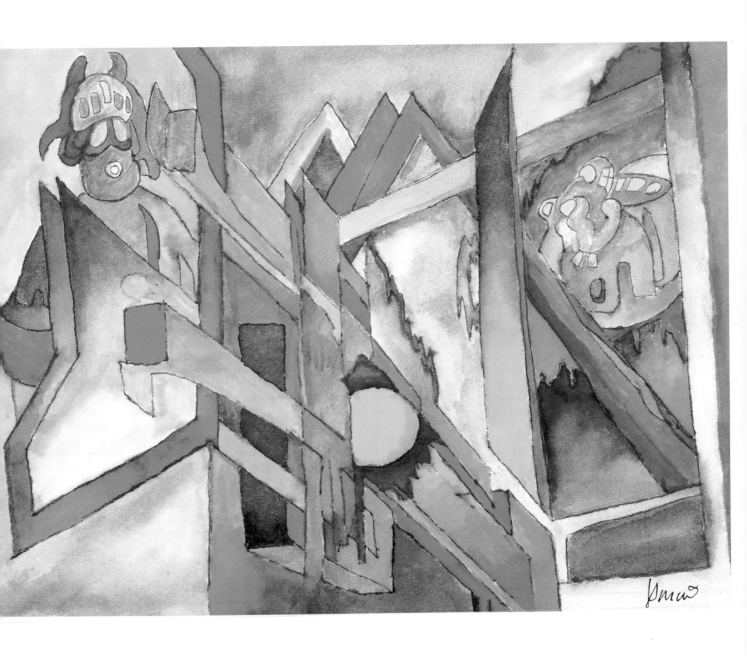

Space Containers 1991
12" x 9"
Ink and Watercolor 75

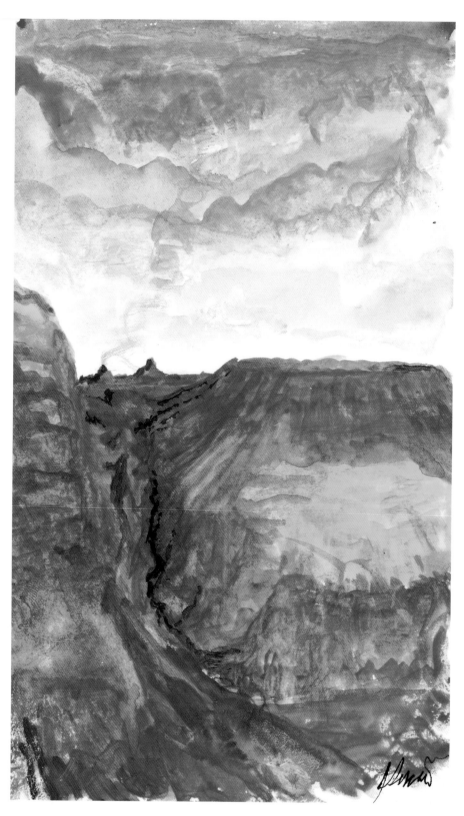

Smoke Signal 1990
5" x 8"
76 Watercolor

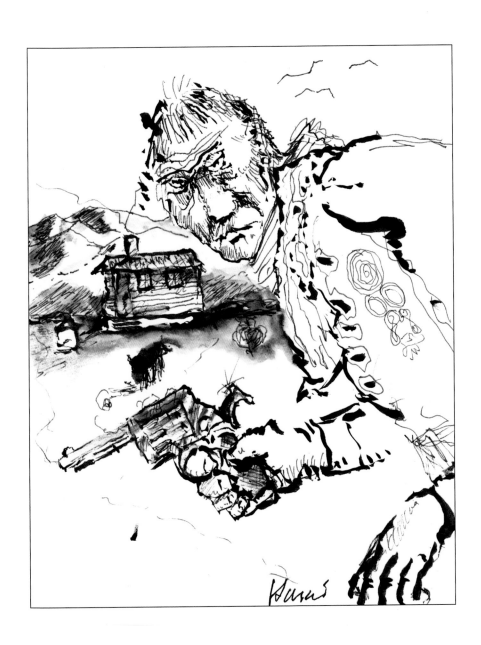

Desert Storm 1990
9" x 12"
78 Watercolor

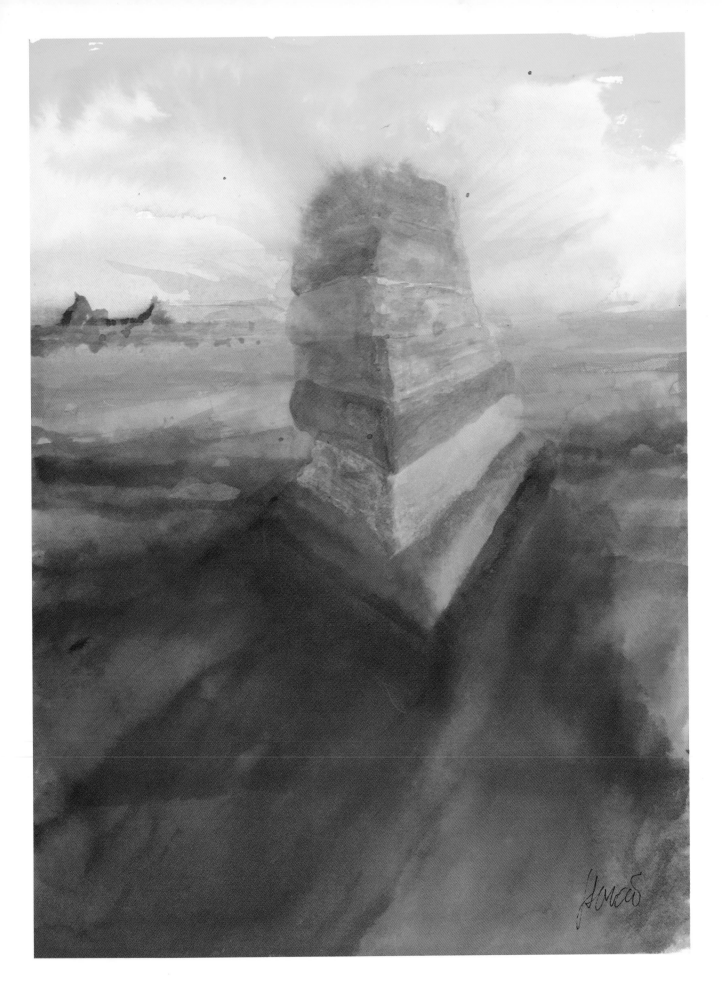

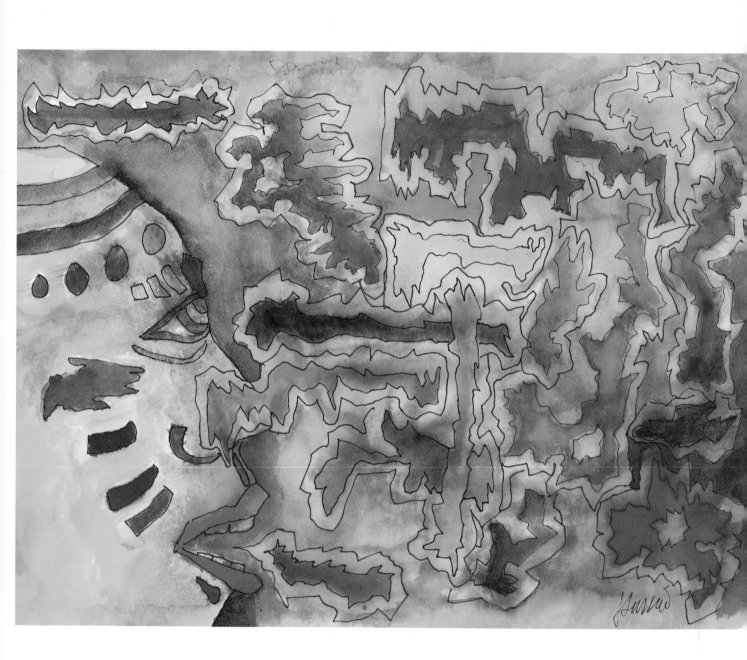

Shaman 1990
12" x 9"
80 Watercolor

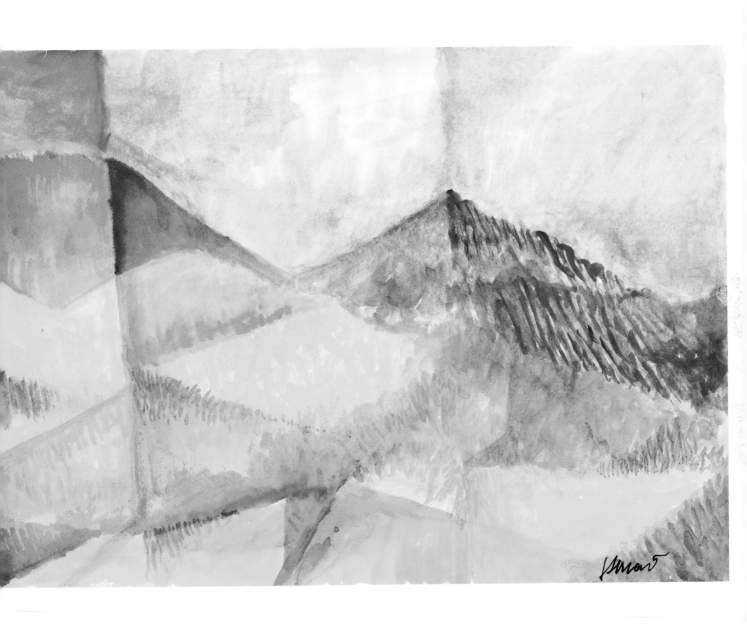

Blue Mountain 1991
12" x 9"
Watercolor 81

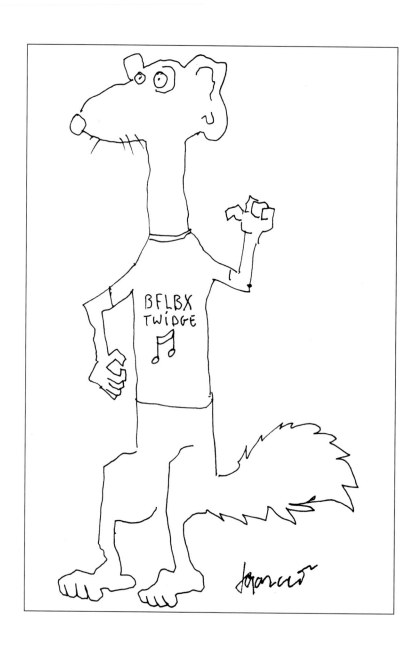

Mr. Twidge 1991
4" x 6"

Ink

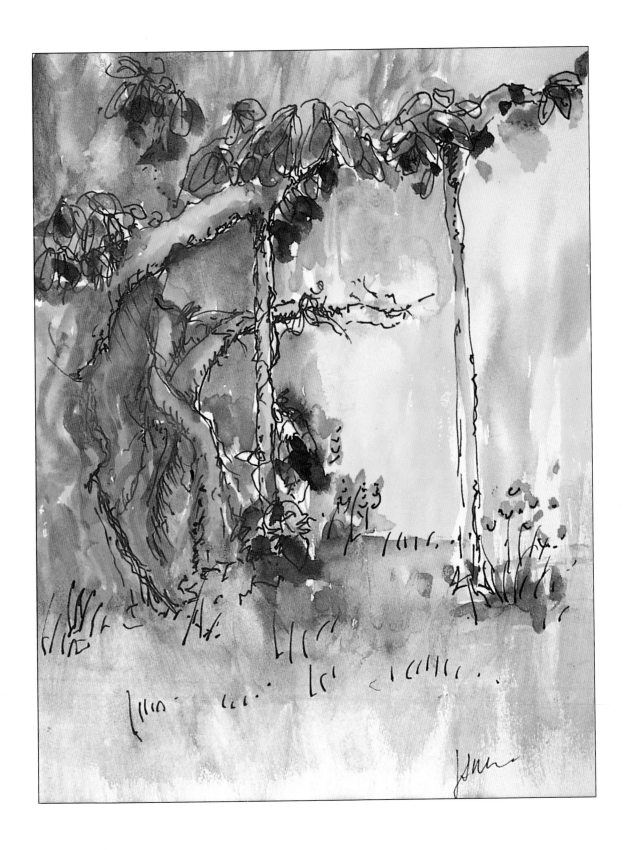

Banyan Trees II 1989
6" x 8"
Ink and Watercolor *83*

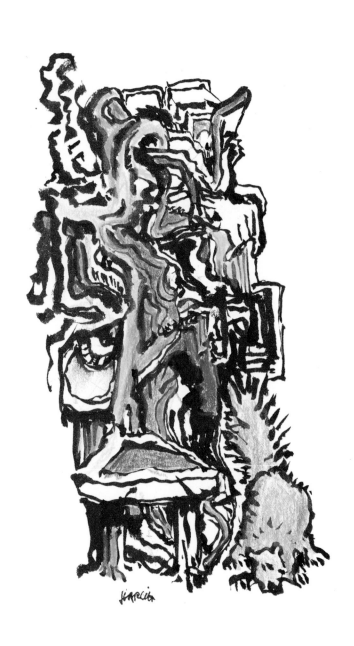

Squirrel Maze 1990
3" x 5"

84 Ink and Colored Pencil

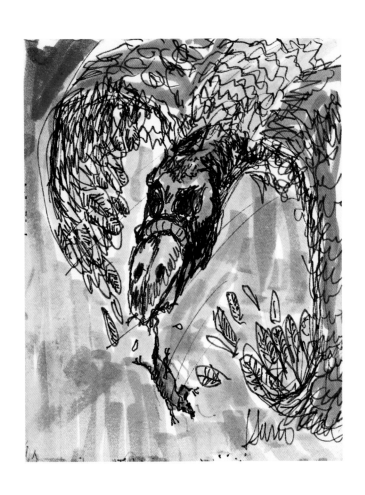

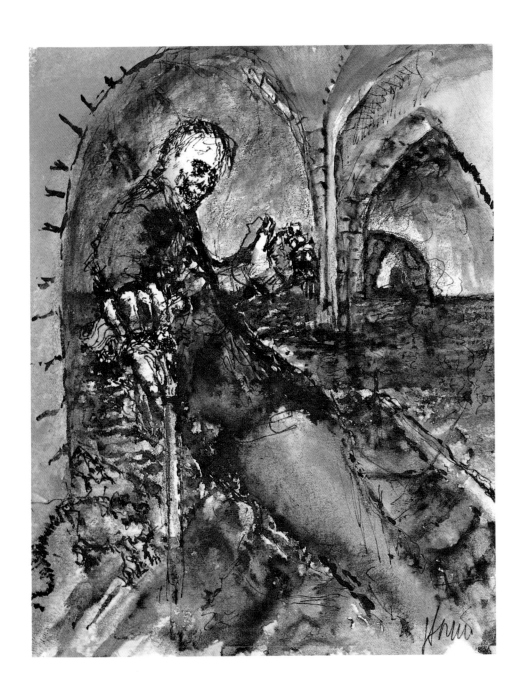

Eric the Phantom 1990
5" x 6"
Ink and Watercolor 87

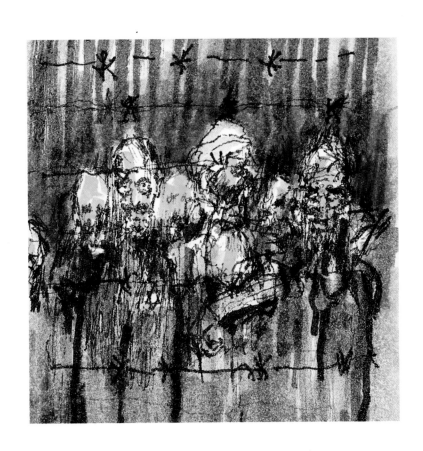

Survivors 1986
4" x 4"
Ink and Colored Marker *89*

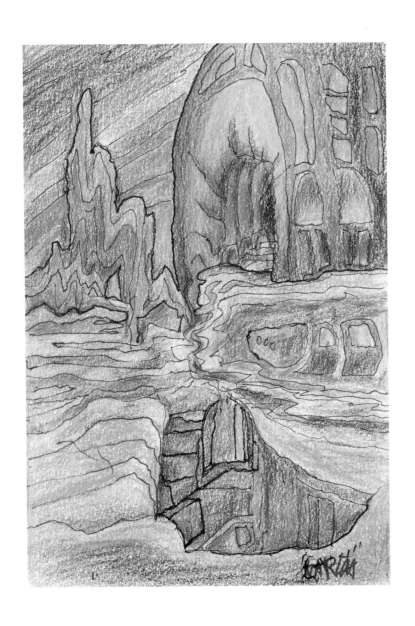

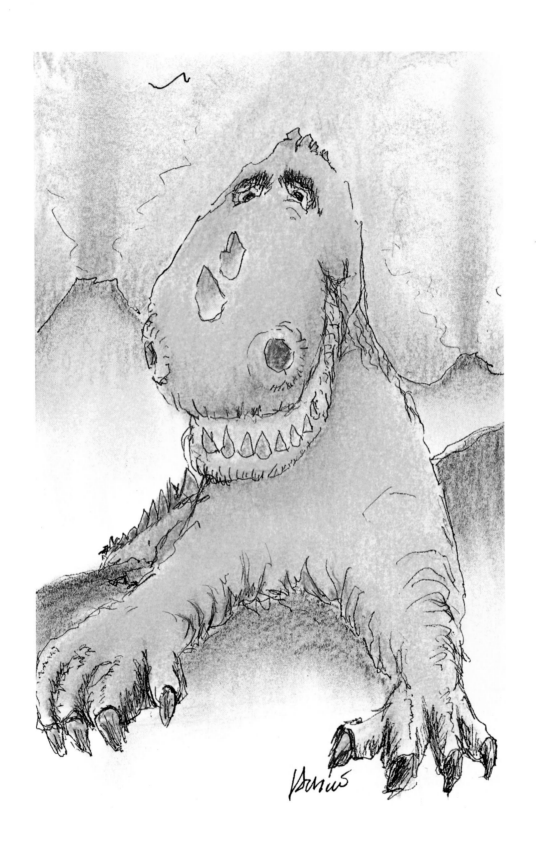

Smile 1991
5" x 8"
Ink and Colored Pencil 93